Flower Wreaths & Garlands
IN CROSS STITCH

Denise Roberts

MEREHURST

THE CHARTS

Some of the designs in this book are very detailed and, due to
inevitable space limitations, the charts may be shown on a compara-
tively small scale; in such cases, readers may find it helpful to have
the particular chart with which they are currently working enlarged.

THREADS

The projects in this book were all stitched with DMC stranded cotton
embroidery threads. The keys given with each chart also list thread
combinations for those who wish to use Anchor or Madeira embroidery
threads. It should be pointed out that the shades produced by different
companies vary slightly, and it is not always possible to find identical
colours in a different range.

Published in 1999 by Merehurst Limited
Ferry House, 51-57 Lacy Road, Putney, London SW15 1PR
Copyright © 1999 Merehurst Limited
ISBN 1 85391 769 9

A catalogue record for this book is available from the British Library.

Editor: Diana Lodge
Designer: Maggie Aldred
Photographer: Juliet Piddington
Illustrators: King & King Design Associates and John Hutchinson
Senior Commissioning Editor: Karen Hemingway
CEO & Publisher: Anne Wilson
International Sales Director: Mark Newman
Colour separation by Bright Arts (HK) Ltd
Printed in Hong Kong by Wing King Tong

*Merehurst is the leading publisher of craft books and has an excellent
range of titles to suit all levels. Please send to the address above for our
free catalogue, stating the title of this book.*

CONTENTS

INTRODUCTION

Flowers have been one of the most popular subjects for all types of embroidery for hundreds of years, and floral wreaths and garlands have been used for decoration and to commemorate occasions and events of all kinds in all parts of the world for even longer. In this book these traditions are continued, using cross-stitched wreaths and garlands to embellish a variety of functional and attractive items to decorate the home, or to give as gifts or mementoes to celebrate various occasions.

There are designs to suit all levels of ability and experience. Some are relatively intricate, incorporating a mixture of fractional stitches, subtle colour changes, metallic threads, beads and variegated threads, and worked on a variety of fabrics. Other designs are quick and easy to embroider and could be stitched by a newcomer to cross stitch.

Most of the designs are versatile, and could therefore easily be adapted to decorate many different items. The larger designs could be used for framed pictures, cushions or place-mats, for example. Most of the smaller designs would fit well into cards, coasters, trinket pots or paperweights.

If you thought wreaths and garlands were just circles of flowers, this book will change your mind. Many of these designs stretch the concept to the limit and will, I hope, provide interesting, enjoyable and challenging projects, suitable for stitchers of all levels of ability and experience to embroider for a variety of occasions and uses.

BASIC SKILLS

BEFORE YOU BEGIN

PREPARING THE FABRIC
Even with an average amount of handling, many evenweave fabrics tend to fray at the edges, so it is a good idea to overcast the raw edges, using ordinary sewing thread, before you begin.

FABRIC
Most of the projects in this book use Aida fabric, which is ideal both for beginners and more advanced stitchers as it has a surface of clearly designated squares, each cross stitch being worked over a square. Other projects use evenweave Quaker, Brittney or Linda fabrics, which have 28 or 27 threads per 2.5cm (1in) each way, but in these cases the stitches are worked over two threads.

All evenweaves have a count, referring to the number of Aida blocks, threads or perforations, per 2.5cm (1in) in each direction. The lower the count, therefore, the larger the finished stitching. If you wish to use fabric with a different stitch count, count the maximum number of stitches on the chart horizontally and vertically and divide these numbers by the stitch count of your chosen fabric; this will give you the dimensions of the design when stitched on your fabric.

THE INSTRUCTIONS
Each project begins with a full list of the materials that you will require. The measurements given for the embroidery fabric include a minimum of 5cm (2in) all around to allow for preparing the edges to prevent them from fraying.

Colour keys for stranded embroidery cottons — DMC, Anchor or Madeira — are given with each chart. It is assumed that you will need to buy one skein of each colour mentioned in a particular key, even though you may use less.

In some instances, only very short lengths of thread are used: perhaps a couple of stitches in white, or dots of yellow for flower centres. For this reason, if you intend to embroider for your friends

on a fairly regular basis, it would be useful to have threads in a few standard colours – particularly white, yellow and black, and also red, blue, green, orange and brown. If you already have yellow, for example, you will then have no need to buy a skein of a slightly different shade when you are simply using the colour for a tiny flower centre.

Where metallic threads have been used, the specific make of thread is listed, without giving any equivalent. Several manufacturers produce these threads, but each brand will vary significantly, and it is not always possible to find a close equivalent. If you are unable to obtain the named thread, you may be able to substitute a similar thread for an equally attractive, if perhaps slightly different, effect, but you should experiment to ensure that you achieve a good coverage of the fabric before using it in your finished embroidery.

Before you begin to embroider, always mark the centre of the design with two lines of basting stitches, one vertical and one horizontal, running from edge to edge of the fabric (to find the centre on the chart, count the maximum number of stitches each way and divide by two).

As you stitch, use the centre lines given on the chart and the basting threads on your fabric as reference points for counting the squares and threads to position your design accurately.

WORKING IN A HOOP

A hoop is the most popular frame for use with small areas of embroidery. It consists of two rings, one fitted inside the other; the outer ring usually has an adjustable screw attachment so that it can be tightened to hold the stretched fabric in place. Hoops are available in several sizes, ranging from 10cm (4in) in diameter to quilting hoops with a

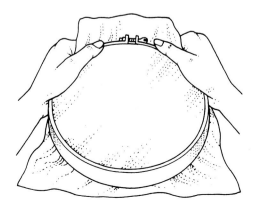

diameter of 38cm (15in). Hoops with table stands or floor stands attached are also available.

1 To stretch your fabric in a hoop, place the area to be embroidered over the inner ring and press the outer ring over it, with the tension screw released. Tissue paper can be placed between the outer ring and the embroidery, so that the hoop does not mark the fabric. Lay the tissue paper over the fabric when you set it in the hoop, then tear away the cental embroidery area.

2 Smooth the fabric and, if necessary, straighten the grain before tightening the screw. The fabric should be evenly stretched.

WORKING IN A RECTANGULAR FRAME

Rectangular frames are more suitable for larger pieces of embroidery. They consist of two rollers, with tapes attached, and two flat side pieces, which slot into the rollers and are held in place by pegs or screw attachments. Available in different sizes, either alone or with adjustable table or floor stands, frames are measured by the length of the roller tape, and range in size from 30cm (12in) to 68cm (27in). As alternatives to a slate frame, canvas stretchers and the backs of old picture frames can be used. Provided there is sufficient extra fabric around the finished size of the embroidery, the edges can be turned under and simply attached with drawing pins (thumb tacks) or staples.

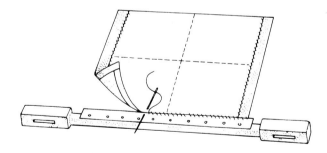

1 To stretch your fabric in a rectangular frame, cut out the fabric, allowing at least an extra 5cm (2in) all around the finished size of the embroidery. Baste a single 12mm (½in) turning on the top and bottom edges and oversew strong tape, 2.5cm (1in) wide, to the other two sides. Mark the centre line both ways with basting stitches. Working from the centre outward and using strong thread, oversew the top and bottom edges to the roller tapes. Fit the side pieces

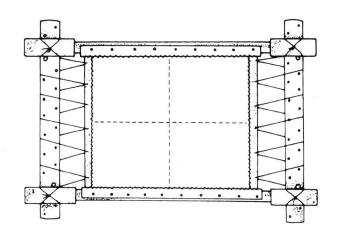

into the slots, and roll any extra fabric on one roller until the fabric is taut.

2 Insert the pegs or adjust the screw attachments to secure the frame. Thread a large-eyed needle (chenille needle) with strong thread or fine string and lace both edges, securing the ends around the intersections of the frame. Lace the webbing at 2.5cm (1in) intervals, stretching the fabric evenly.

EXTENDING EMBROIDERY FABRIC

It is easy to extend a piece of embroidery fabric, such as a bookmark, to stretch it in a hoop.

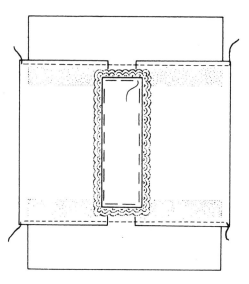

• Fabric oddments of a similar weight can be used. Simply cut four pieces to size (in other words, to the measurement that will fit both the embroidery fabric and your hoop) and baste them to each side of the embroidery fabric before stretching it in the hoop in the usual way.

CROSS STITCH

For all cross stitch embroidery, the following two methods of working are used. In each case, neat rows of vertical stitches are produced on the back of the fabric.

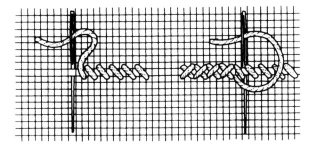

• When stitching large areas, work in horizontal rows. Working from right to left, complete the first row of evenly spaced diagonal stitches over the number of threads specified in the project instructions. Then, working from left to right, repeat the process. Continue in this way, making sure each stitch crosses in the same direction.

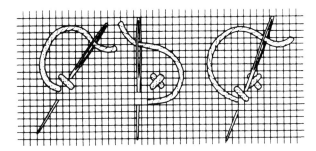

• When stitching diagonal lines, work downwards, completing each stitch before moving to the next. When starting a project, always begin to embroider at the centre of the design and work outwards to ensure that the design will be placed centrally on the fabric.

BACKSTITCH

Backstitch is used in the projects to give emphasis to a particular foldline, an outline or a shadow. The stitches are worked over the same number of threads as the cross stitch, forming continuous straight or diagonal lines.

• Make the first stitch from left to right; pass the needle behind the fabric and bring it out one stitch

length ahead to the left. Repeat and continue in this way along the line.

To give a rounded effect on curves in some designs, backstitch is laid over two squares to give a 'long-line' and is usually placed over a three-quarter stitch which fills the largest portion of the fabric to be outlined.

THREE-QUARTER CROSS STITCH

Some fractional stitches are used on certain projects in this book; although they strike fear into the hearts of less experienced stitchers they are not difficult to master, and give a more natural line in certain instances. Should you find it difficult to pierce the centre of the Aida block, simply use a sharp needle to make a small hole in the centre first.

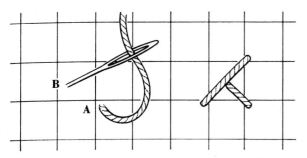

To work a three-quarter cross, bring the needle up at point A and down through the centre of the square at B. Later, a diagonal back stitch finishes the stitch. A chart square with two different symbols separated by a diagonal line requires two 'three-quarter' stitches. Backstitch will later finish the square.

FRENCH KNOTS

This stitch is used in certain of the projects and can also be used as an alternative to beading, if you choose. To work a French knot, bring your needle

and cotton out slightly to the right of where you want your knot to be. Wind the thread once or twice around the needle, depending on how big you want your knot to be, and insert the needle to the left of the point where you brought it out.

Be careful not to pull too hard or the knot will disappear through the fabric. Unless otherwise instructed use two strands of thread in the needle.

FINISHING

MOUNTING EMBROIDERY

The cardboard should be cut to the size of the finished embroidery, with an extra amount added all round to allow for the recess in the frame.

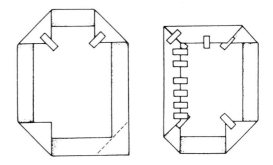

LIGHTWEIGHT FABRICS

1 Place the embroidery face down, with the cardboard centred on top, and basting and pencil lines matching. Begin by folding over the fabric at each corner and securing it with masking tape.

2 Working first on one side and then the other, fold over the fabric on all sides and secure it firmly with pieces of masking tape which are placed about 2.5cm (1in) apart. Also neaten the mitred corners with masking tape, pulling the fabric tightly to give a firm, smooth finish.

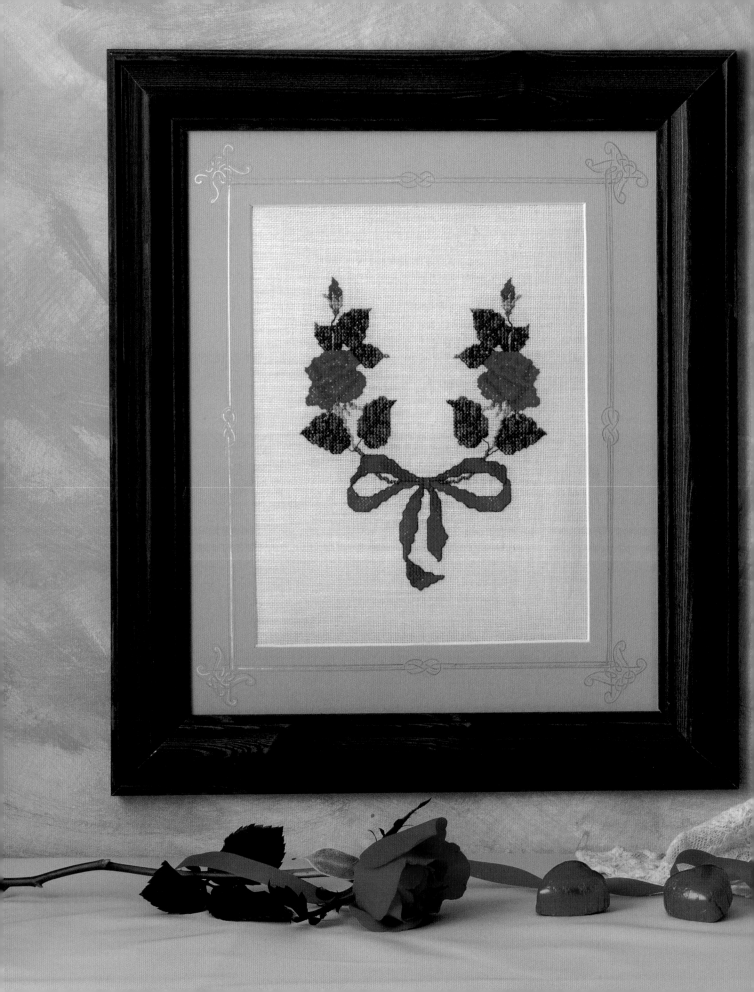

Ribbons and Roses

This picture is an ideal gift for a romantic occasion, such as a wedding or an anniversary. The design could include initials and a date, and the more adventurous stitcher could change the colour of the roses to suit the occasion.

RIBBONS AND ROSES

YOU WILL NEED
For the rose picture, mounted in a wooden frame with a 25cm x 30cm (10in x 12in) aperture, with a coloured mount with a 17.5cm x 22.5cm (7in x 9in) aperture:

45.5cm x 38cm (18in x 15in) of 28-count Quaker cloth, in cream
Stranded embroidery cotton in the colours given in the panel
No26 tapestry needle
Strong thread for lacing across the back when mounting
Coloured mount to fit the frame, with an aperture as specified above
Stiff acid-free cardboard, to fit the frame recess
Frame of your choice, with an aperture as specified above
2oz polyester wadding (optional), the same size as the frame aperture, to insert between the embroidery and the cardboard to give slightly padded effect to the framed picture

●

THE EMBROIDERY
Prepare the fabric as described on page 4, marking the centre lines with basting stitches. Set the fabric in a hoop or frame (see page 5) and, starting from a convenient point (such as the centre of the bow), embroider the cross stitches with two strands of stranded cotton. Finish with the backstitching, using one strand. Steam press the finished embroidery on the wrong side.

FRAMING THE PICTURE
If you want the slightly padded effect, cut a piece of wadding to the exact size of the aperture of the mount; place the wadding in the centre of the backing cardboard and, if necessary, fix it by putting a dab of adhesive at each corner of the wadding. Lace the embroidery over the cardboard, following the instructions for mounting (see below). Insert the mount and then the mounted embroidery into the frame. Finally, assemble the frame according to the manufacturer's instructions.

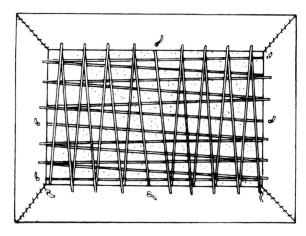

Lay the embroidery face down, with the cardboard centred on top; fold over the edges of the fabric on opposite sides, making mitred folds at the corners, and lace across, using strong thread. Repeat on the other two sides. Finally, pull up the fabric firmly over the cardboard. Overstitch the mitred corners. This method is suitable for larger pictures and heavier fabrics; for lightweight fabrics and smaller embroideries, use the method described on page 7.

▶ RIBBONS AND ROSES			
	DMC	ANCHOR	MADEIRA
⊞ Bright red	321	47	0510
▪▪ Dark red	815	43	0513
▽ Leaf green	905	258	1413
⊐ Bright green	906	256	1411
◯ Apple green	907	255	1410
▼ Dark green	986	246	1404
◸ Light red	3801	335	0209
Very dark red*	902	897	0811

*Note: backstitch bow outline with very dark red (*used for backstitching only) and stems of leaves and buds with dark green.*

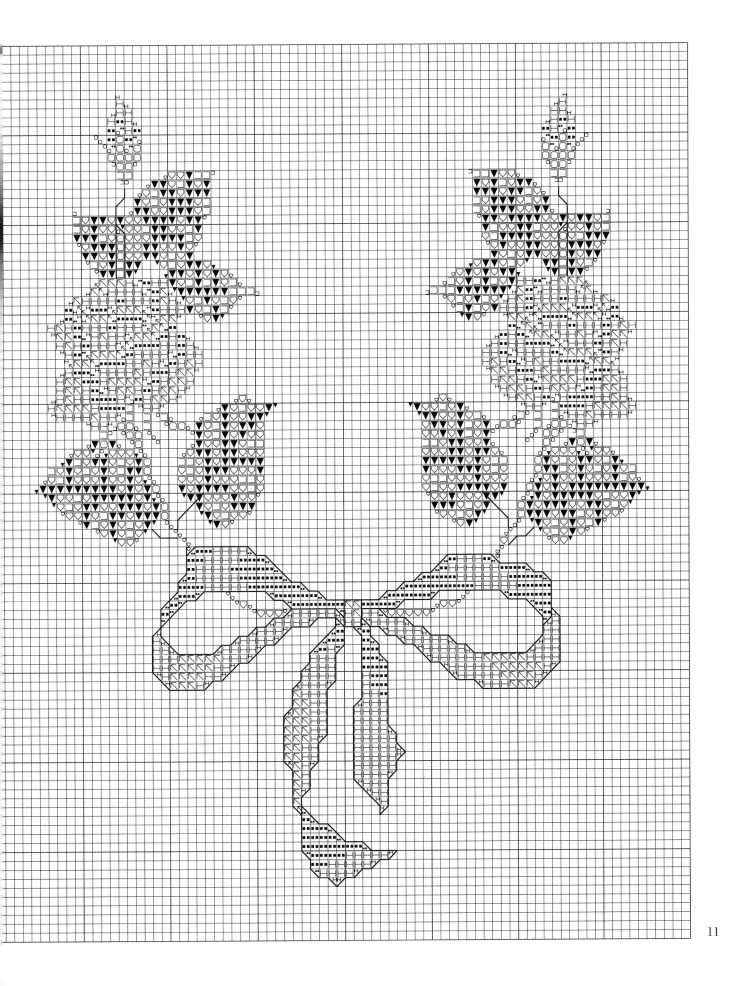

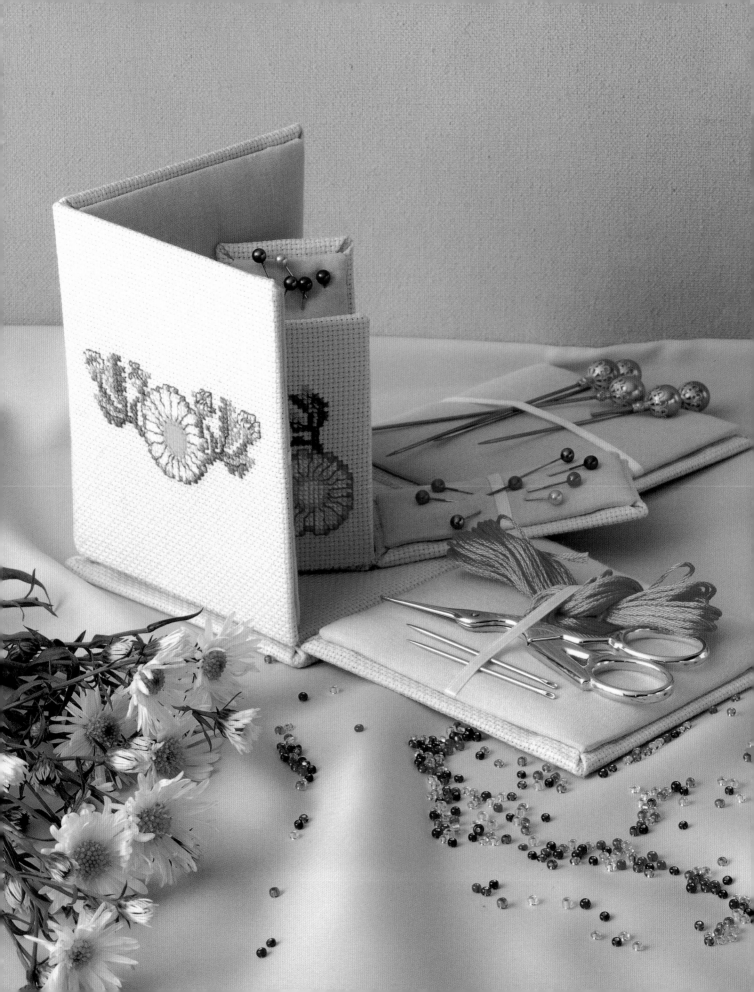

Daisy Needlework Box

Stylized daisies, inspired by Art Nouveau illustrations of the late Victorian period, provide an ideal decoration for a Victorian-style needlework box.

DAISY NEEDLEWORK BOX

YOU WILL NEED
For the needlework box, 10cm (4in) high, with a
lid 9cm (3½in) square:

*45cm (18in) square of 18-count Aida fabric, in
eau-de-nil
Stranded embroidery cotton in the colours given
in the panel
No26 tapestry needle
Box kit, available from needlework stockists
complete with cardboard cut-outs and full
illustrated instructions for box construction
(for suppliers, see page 40)
Coordinating lining fabric and narrow ribbon, 2oz
polyester wadding, all-purpose adhesive and
matching sewing thread, as given in box
kit instructions*

•

THE EMBROIDERY

When making up the box, the Aida fabric is cut to
cover the various sections, as explained in the box
kit instructions. You will find that it is easier to
embroider the design before cutting out the fabric.
Start by placing the relevant cardboard cut-outs on
the Aida fabric and drawing around them, remem-
bering to add seam allowances. Mark the centre of
each piece to be embroidered with horizontal and
vertical lines of basting stitches before placing the
fabric in a hoop or frame (see page 5). Some of the
pieces of outer fabric will not need to be embroi-
dered but you will need to draw around all pieces to
make sure enough fabric is allowed for all the pieces
of the box covered with Aida.

Embroider one full garland for the lid, four of the
larger single flower designs for the outer sides of the
box, and four of the smaller single flower designs for
the inner flaps of the box. If you do not wish to dec-
orate all the sides, you could embroider the lid only,
or just the lid and outer sides, leaving the rest plain.
Complete the cross stitches first, using two strands
of thread in the needle, and then use one strand for
the backstitching.

When the embroidery is complete, place the fab-
ric face down on a thick towel and steam press
before cutting out the sections. Construct the box as
given in the box kit instructions.

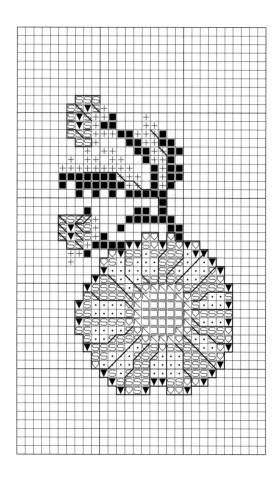

▶ DAISY GARLANDS				
		DMC	ANCHOR	MADEIRA
•	White	Blanc	01	White
⊐	Yellow	444	290	0106
▼	Dark pink	602	057	0702
▽	Medium pink	604	055	0614
◥	Orange	741	304	0201
S	Pale pink	818	023	0502
■	Green	911	205	1214
+	Light green	954	203	1211
	Cerise*	600	078	0704
	Dark green*	909	923	1303

*Note: backstitch all flower details in cerise and all leaf details in
dark green (*starred colours are used for backstitching only).*

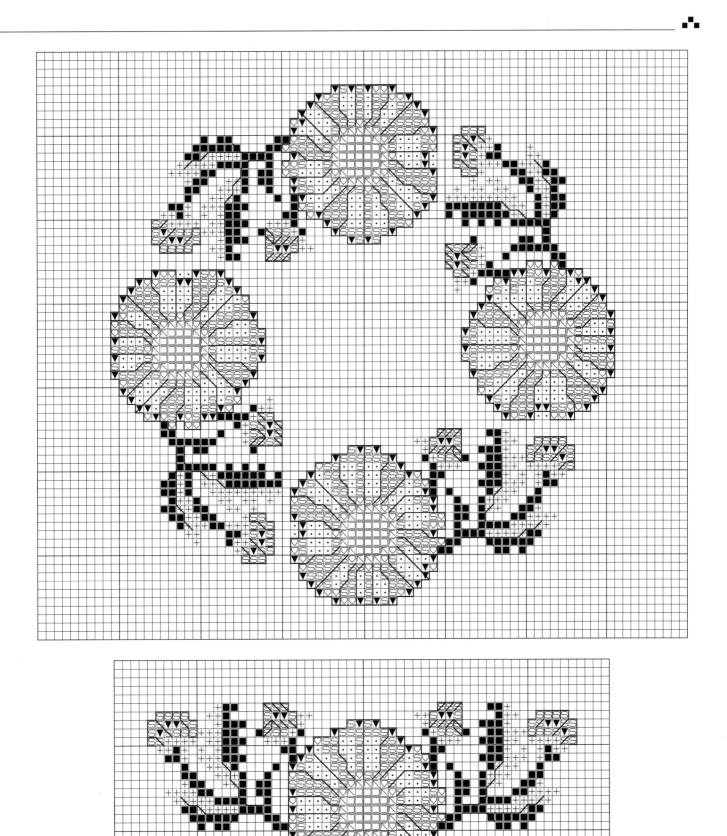

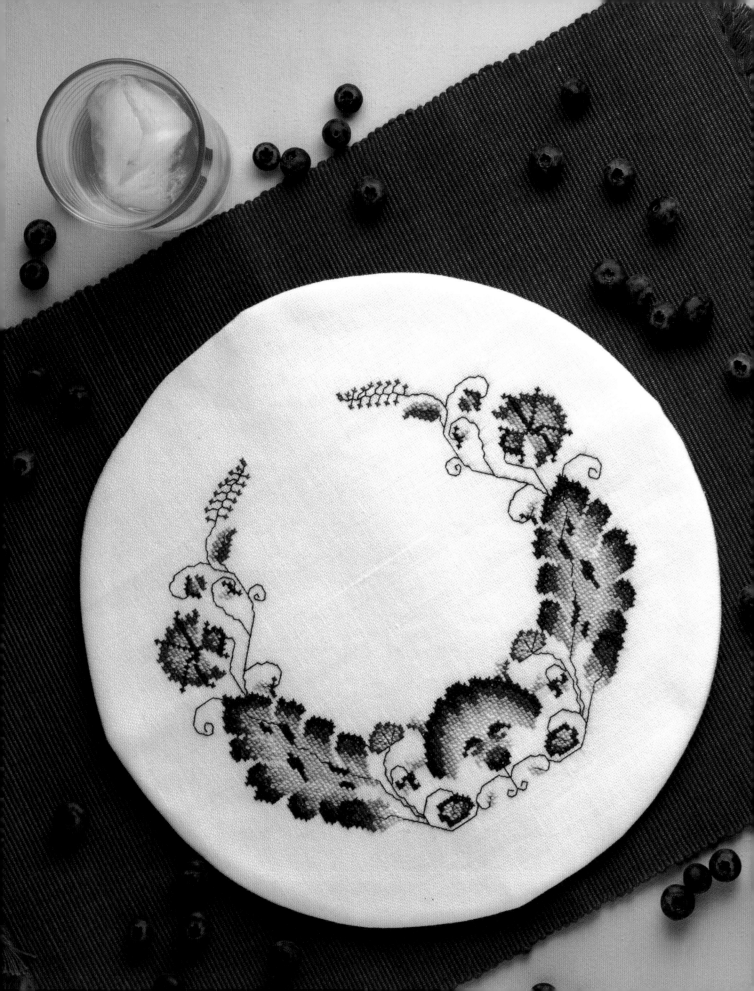

Crewel-style Place Setting

Worked in only six shades of blue, this garland combines the flowing curves and stylized leaves of 17th-century crewel work with the cool blues of traditional pottery designs to create a look which is perfect for modern table linen.

CREWEL-STYLE PLACE SETTING

YOU WILL NEED

For the table napkin, measuring 28cm (15in) square:

*39cm (15½in) square of 28-count Brittney
evenweave fabric, in white
Stranded embroidery cotton in the colours given in
the panel
No26 tapestry needle
Madeira rayon machine embroidery thread,
Art No 9840, shade 2016, blue mix
(for the satin-stitched hem)*

Note: Madeira rayon machine embroidery thread
has been used for the edging; there is no exact
equivalent in the other brands listed, but you can
substitute other machine threads, provided you
obtain an attractive effect.

For the placemat, measuring 28cm (11in)
in diameter:

*37.5cm (13in) square of 28-count Brittney
evenweave fabric, in white
Stranded embroidery cotton in the colours given in
the panel
No 26 tapestry needle
37.5cm (13in) square of heat-proof felt wadding,
available from good needlework stockists
37.5cm (13in) square of white backing fabric*

•

THE TABLE NAPKIN

It is advisable to hem the napkin before embroider-
ing the design. Fold, press and baste in place a
12mm (½in) hem around all the edges. Mitre each
corner by trimming about 6mm (¼in) from the
point, folding in the remaining fabric diagonally, so
that the foldline crosses the hemline at the corner,
and then turning in the hem, butting the folded
edges together. Stitch the hem in place by enclosing
the raw edges with a narrow machined satin stitch,
using rayon machine embroidery thread.

The napkin could be hemmed in other ways, but
for some methods such as fringing or traditional
drawn-thread edgings you would need to add an
extra hem allowance.

Work the embroidery in a corner of the napkin,
starting with the bottom right corner of the design.
Use two strands of thread over two threads of the
fabric for the cross stitches and then embroider the
backstitches, this time using one strand of thread
over two threads of the fabric.

THE PLACEMAT

For each mat, prepare the fabric as described on page
4, marking the centre lines with basting stitches, and
set it in a hoop or frame. Begin by counting from the
centre to the nearest convenient point: the large cen-
tral flower at the base of the design is a good starting
point. Use two strands of thread over two threads of
the fabric for the cross stitches and then embroider
the backstitches, now using one strand of thread over
two threads of the fabric. Remove the finished
embroidery from the hoop or frame and steam press
the embroidery on the wrong side.

Keeping the design centred, draw a circle 30cm
(12in) in diameter on the embroidered fabric, the
wadding and backing fabric. I found the easiest way
to do this was to use the inside line of a 30cm (12in)
embroidery hoop as a template, drawing the lines
with a yellow quilter's marking pencil. Cut out each
circle; place the embroidered fabric and backing
fabric with right sides together, and then put the
wadding on top of the wrong side of embroidery.
Baste the pieces together, then machine stitch,
12mm (½in) from the edge, leaving an opening of
7.5cm (3in) for turning through.

Trim the wadding close to the stitching and trim
the remaining seam allowances back to 6mm (¼in).
Gently easing it into shape, turn the placemat
through to the right side. Close the opening with
slipstitching. Place the embroidered side of the mat
face down on a thick towel and press gently, making
sure the edges curve smoothly into a circle.

▶ BLUE GARLAND		DMC	ANCHOR	MADEIRA
■	Dark navy blue	336	150	1007
+	Powder blue	775	128	1001
S	Royal blue	797	132	0912
⊐	Light blue	800	144	0908
K	Medium blue	809	130	0909
O	Ice blue	3756	1037	1104

*Note: embroider all backstitch details with one strand of
dark navy blue.*

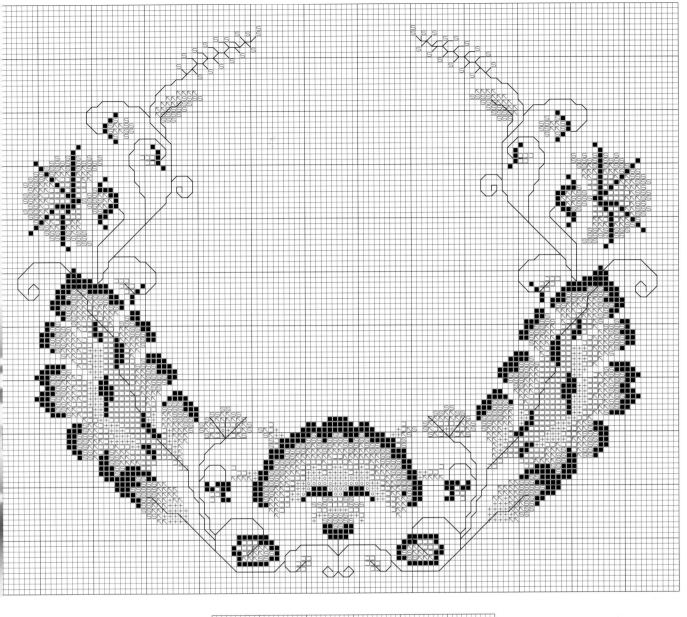

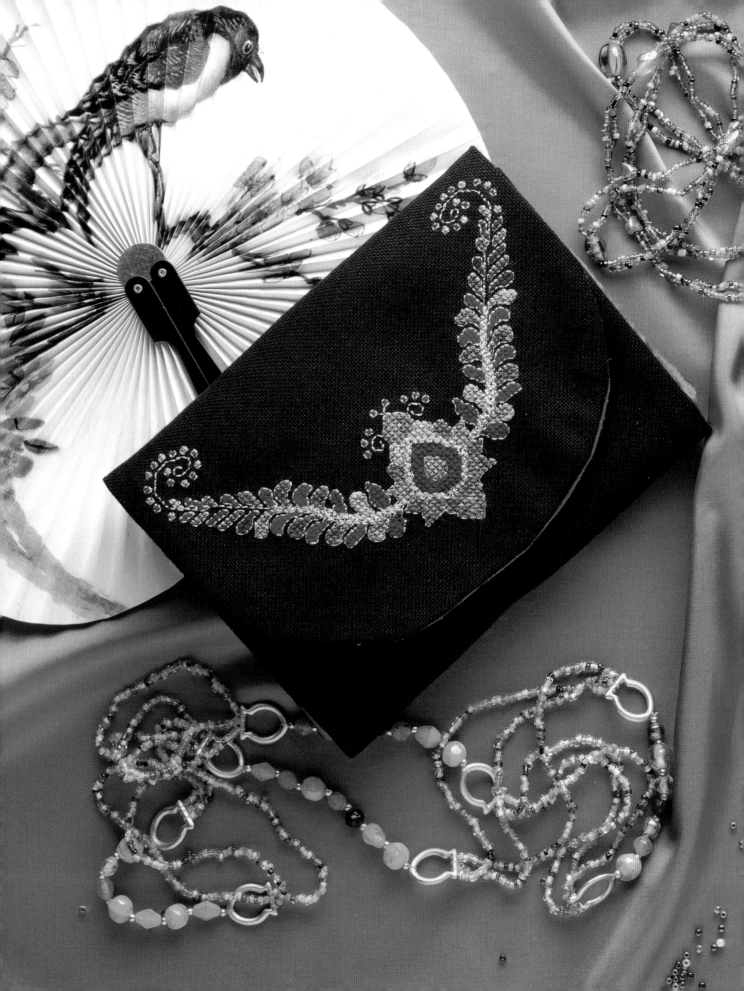

Jewellery Roll and Box

Keep your trinkets and pieces of jewellery in a romantic trinket pot and a rich and luxurious jewellery roll, both adorned with cross stitch inspired by traditional oriental designs. The heart would also be ideal for a Valentine card.

JEWELLERY ROLL
AND BOX

YOU WILL NEED

For the jewellery roll, measuring 49cm x 17cm
(19½in x 6½in) when opened out:

*52cm x 21cm (20½in x 8¼in) of 27-count Linda
fabric, in black*
*Stranded embroidery cotton in the colours given in
the appropriate panel*
Gold threads as given in the appropriate panel
No26 tapestry needle
*52cm x 21cm (20½in x 8¼in) of 2oz wadding,
plus scraps for ring roll*
*Three pieces of lining fabric as follows: one piece
79cm x 21cm (31in x 8¼in), this includes turnings
at each end which form the large pockets; one piece
14cm x 21cm (5½in x 8¼in), for small
pockets, and one piece 8cm x 21cm (3in x 8¼in),
for ring roll*
*Two small strips of black velcro or two press studs
(poppers), for fastenings*

Note: there is no exact equivalent for the
variegated cotton threads in Madeira and no exact
match for the metallic threads in either Madeira or
Anchor, but you can substitute different threads,
provided you obtain an attractive effect.

For the trinket pot lid, with an inset 9cm (3½in)
in diameter:

*15cm (6in) square of 28-count Quaker evenweave
fabric, in white*
*Stranded embroidery cotton in the colours given in
the appropriate panel*
No26 tapestry needle
*Burgundy trinket pot, with a lid with an inset as
specified above (for suppliers see page 40)*

●

THE EMBROIDERY

The embroidery fabric for the jewellery roll only
includes normal seam allowances, so first oversew
the edges or protect them with masking tape to pre-
vent fraying. Divide the prepared fabric into four
equal sections by basting three lines 13cm (5in)
apart across the width. Baste horizontal and vertical
centre lines across one of the end sections and
embroider in this section. Embroider all cross
stitches with two strands of thread and backstitch
with one strand of gold metallic thread. When work-
ing with metallic thread, use quite short lengths and
knot the thread at the eye of the needle to prevent
slipping. When stitching with the variegated thread,
select lengths of thread which shade strongly from
dark to light rather than more evenly shaded
lengths. Work each complete cross separately rather
than stitching in rows.

For the trinket pot, prepare the fabric as described
on page 4. Embroider all cross stitches with two
strands of thread and backstitch with one strand of
thread. When the embroidery is complete, steam
press gently on the wrong side. Assemble the trinket
pot lid according to the manufacturer's instructions.

THE JEWELLERY ROLL

Hem both short ends of the largest piece of lining
fabric: turn under and press a 6mm (¼in) hem and
then turn a further 6mm (¼in), enclosing the raw
edges. Stitch the hems by hand or machine. Also
hem one 21cm (8in) edge of the piece of lining fab-
ric measuring 14cm x 21cm (5½in x 8in).

Fold the large piece of lining fabric in half and
mark the centre line across the width with basting
stitches. With right sides together, place the raw
21cm (8¼in) edge of the small pocket piece 12mm
(½in) from this line and stitch in place along centre
line. Turn the pocket piece right side up, enclosing
the raw edge, and stitch down the centre of the
pocket, through both fabrics, dividing it in two.

For the larger pockets, turn 13cm (5in) in at each
hemmed edge and baste in position (all pockets are
on the same side of the lining). On the wrong side of
the Linda fabric, draw a curve around the embroi-
dered edge. Place lining and main fabrics right
sides together, then place the wadding on top. Pin,
baste and machine stitch through all layers, taking
a seam allowance of 12mm (½in). Stitch smoothly
around the curve and leave the opposite end open
for turning through. Trim the wadding close to the
stitching and trim the curve 12mm (½in) from the
stitching. Clip the seam allowance around the curve
and turn the roll right side out. Press lightly around
the edges; turn in seam allowances at the open end,
and slipstitch them together.

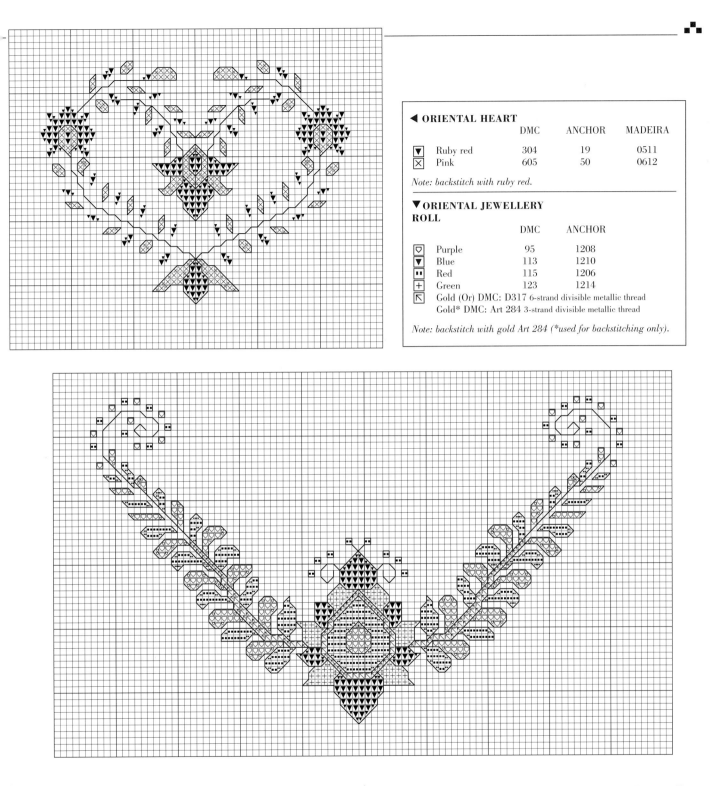

◄ ORIENTAL HEART			
	DMC	ANCHOR	MADEIRA
▼ Ruby red	304	19	0511
☒ Pink	605	50	0612

Note: backstitch with ruby red.

▼ ORIENTAL JEWELLERY ROLL		
	DMC	ANCHOR
▽ Purple	95	1208
▼ Blue	113	1210
▪▪ Red	115	1206
＋ Green	123	1214
◥ Gold (Or) DMC: D317 6-strand divisible metallic thread		
Gold* DMC: Art 284 3-strand divisible metallic thread		

*Note: backstitch with gold Art 284 (*used for backstitching only).*

To make a small ring roll, fold the remaining strip of lining fabric in half and stitch along the long side and one short side, 12mm (¹/2in) from the raw edges.

Clip the corners and turn through to right side. Fill lightly with scraps of wadding and then turn in the raw end and slipstitch across the opening. Place the ring roll inside the jewellery roll, in the centre of the section with no pockets; stitch one end of the ring roll a fraction from the edge of the jewellery roll. Stitch a small piece of velcro or a press stud (popper) to the other end of the ring roll and the appropriate point on the inside of the jewellery roll.

Roll up the jewellery roll so the embroidered section sits on the top. Stitch a velcro strip or press stud on the inside, 12mm (¹/2in) in from the centre edge of the curve, to make a sure fastening.

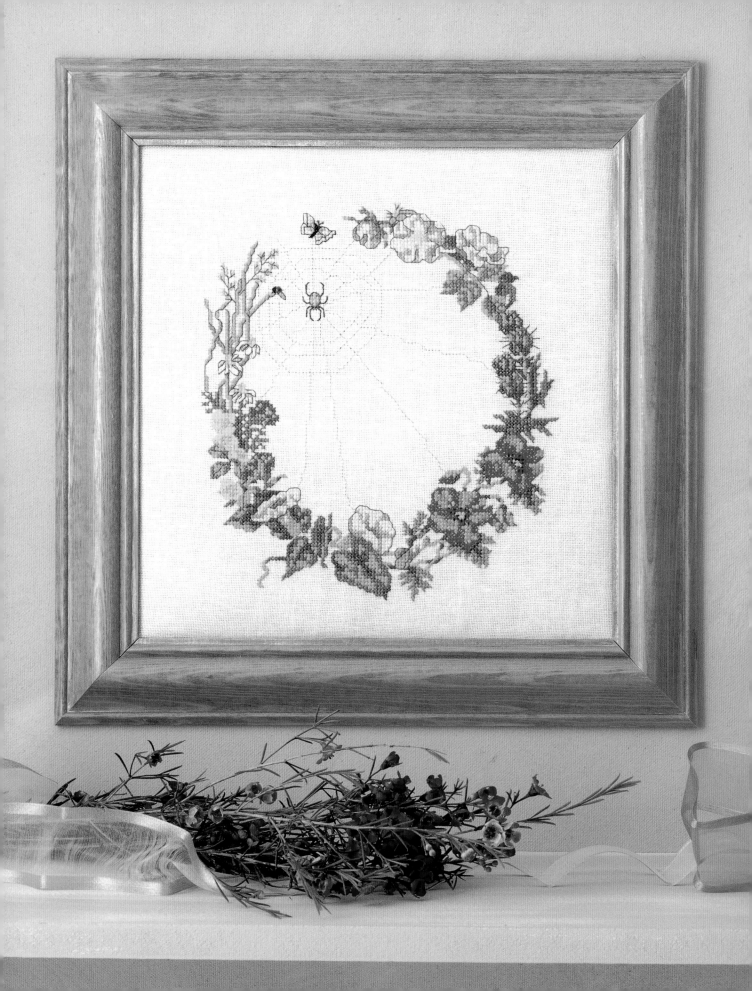

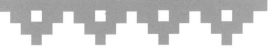

Wild Flower Garland

The fleeting beauty of wild flowers
and a shimmering spider's web
evoke sunny days in the country.
Capture these images to enjoy all
year round by stitching this garland
– an enjoyable challenge for the
more experienced stitcher.

WILD FLOWER GARLAND

YOU WILL NEED

For the picture, mounted in a square frame with an aperture measuring 24cm (9¹/2in) each way:

40cm (16in) square of 28-count Quaker cloth, in antique white
Stranded embroidery cotton in the colours listed in the panel
Silver metallic thread
No26 tapestry needle
Strong thread, for lacing across the back when mounting
Stiff acid-free cardboard, to fit frame recess, for mounting
Frame of your choice
2oz polyester wadding (optional), the same size as the frame aperture, to insert between embroidery and cardboard, giving a slightly padded effect to the framed picture

Note: DMC D317 six-stranded silver metallic thread has been used; there is no exact equivalent in the other brands listed, but you can substitute other silver threads, provided you obtain an attractive effect.

●

THE EMBROIDERY

Prepare the fabric as described on page 4, marking the centre lines with basting stitches. Set it in a hoop or frame (see page 5) and embroider each stitch over two threads of the fabric, using two strands of embroidery cotton for all cross stitches. When you have completed the cross stitches, continue with the French knots and then the back-stitching, this time using one strand for everything except the spider's legs, which should be worked with two strands. When working with metallic thread, it is advisable to use shorter lengths than usual and to knot the thread at the eye of the needle to prevent it from slipping out as you stitch.

FRAMING THE PICTURE

Remove the finished embroidery from the hoop or frame. Place it right side down on a thick towel; cover with a thin cloth to protect the metallic thread, and steam press on the wrong side.

Mount the work as explained on page 10. If you are using wadding, cut this to the exact size of the frame aperture and stick it to the front of your mount board with a dab of glue in each corner before stretching and lacing the work over the board. Place the mounted embroidery in the frame of your choice and complete the assembly according to the manufacturer's instructions.

▶ **WILD FLOWER GARLAND**

		DMC	ANCHOR	MADEIRA
•	White	Blanc	01	White
■	Black	310	403	Black
H	Yellow	307	289	0104
▼	Purple	333	119	0903
▽	Lavender	340	118	0902
O	Pale grey	415	398	1803
S	Medium brown	434	310	2009
2	Light brown	437	362	2012
॥	Moss green	470	267	1407
⊟	Pale green	472	253	1414
::	Flame red	606	335	0209
T	Dark orange	608	332	0207
8	Crimson	666	046	0210
K	Orange	741	304	0201
↑	Medium blue	813	161	1013
Y	Pale blue	828	9159	1101
/	Medium green	905	257	1412
L	Bright green	907	255	1410
コ	Magenta	917	089	0706
∧	Pink	962	075	0609
+	Pale pink	963	073	0608
▶	Dark green	986	246	1404
▬	Dark peach	3340	329	0301
И	Light magenta	3608	086	0709
X	Dark pink	3731	076	0610
V	Gold	3820	306	2202
	Dark grey*	844	1041	809
	Silver (Argent)*	DMC D317 *Divisible 6-Strand Metallic Thread*		
	Cherry red*	326	059	0508

*Note: backstitch the spider's legs with two strands of dark grey (*starred colours used for backstitching only); daisies and butterfly with one strand of dark grey; dog roses and bindweed with one strand of cherry red; thistle prickles, grasses and other foliage details with one strand of dark green, and spider's web with one strand of silver. Work French knots (shown as a tiny circle) with one strand of black for poppy centres, ladybird's spot and butterfly antennae; one strand of yellow on dog roses, and one strand of bright green on buttercups.*

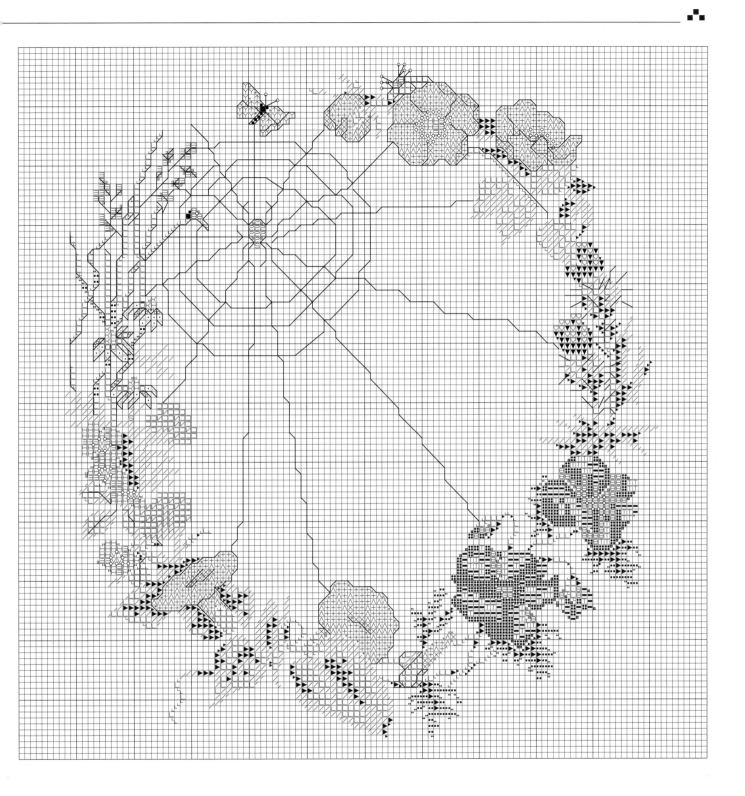

Butterflies and Bows

Brighten your towels with these attractive swags and decorate the bathroom door by stitching a useful finger plate to match. The spiral garland can be lengthened or shortened and worked vertically or horizontally to fit your linen.

BUTTERFLIES AND BOWS

YOU WILL NEED

For the finger plate, measuring 25.5cm x 6.5cm
(1in x 2½in):

30cm x 11cm (12in x 4½in) of 14-count Aida
*Plus fabric, in white (ordinary Aida fabric could be
used, but the stiffness of Aida Plus makes assembly
of the finger plate easier)
Stranded embroidery cotton in the colours given in
the appropriate panel
No26 tapestry needle
Finger plate, as specified above (for stockists, see
page 40)*

For either of the towel borders, each of which
measures approximately 51cm x 86cm
(20in x 34in), with repeats as used here:

*55cm (21½in) of 15-count Aida band, 5cm (2in)
wide, white with white edging
Stranded embroidery cotton in the colours given in
the appropriate panel
No26 tapestry needle
Hand towel in the colour of your choice for the
spiral design and white for the pansy swag design*

•

FINGER PLATE

For the finger plate, mark the centre lines on the
Aida Plus fabric with basting stitches. Work the
cross stitch with two strands of thread and the back
stitch and French knots with one strand. Steam
press the completed embroidery on the wrong side.

TOWEL BANDS

If using Aida Plus, cover the wrong side with a cloth
to prevent the backing sticking to the iron.
Assemble the finger plate according to the manu-
facturer's instructions.

TOWEL BANDS

Towels vary in width, but both designs can easily be
adjusted to fit most hand towel sizes. Make sure that
your Aida band is sufficiently long to run across the
width of the towel and leave a 12mm (½in)
allowance, for turning, at each end.

For each towel band, mark the centre with basting
stitches. It is important to begin stitching at the cen-
tre of the Aida band. For the pansy swag border,
stitch the central swag first and then repeat the swag
design on each side, counting 14 blocks between
each swag. Embroider the cross stitches first, using
two strands of thread in the needle, and then work
the backstitches and French knots, this time using
one strand in the needle.

FLOWER AND RIBBON SPIRALS				
		DMC	ANCHOR	MADEIRA
O	Yellow	444	291	0106
▽	Blue	518	1039	1106
↑	Pale blue	519	1038	1105
K	Purple	552	100	0805
X	Dark pink	601	63	0703
+	Pink	604	55	0614
Y	Orange	740	316	0202
\	Very pale blue	747	158	1104
S	Gold	783	307	2211
▼	Dark green	909	923	1303
⊒	Medium green	911	205	1214
⊐	Light green	913	204	1212
H	Brown	3790	393	1905
∧	Light gold	3820	305	0108

*Note: backstitch butterfly legs and antennae with brown, adding a
brown French knot to the end of each antenna.*

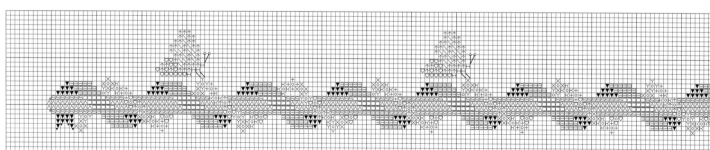

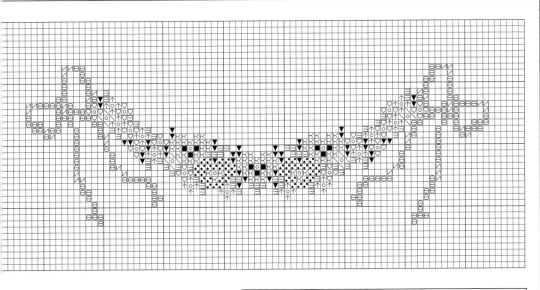

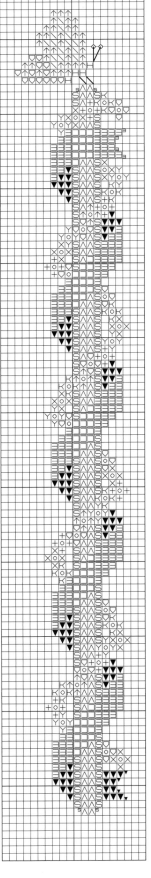

PANSY SWAG ▲				
		DMC	ANCHOR	MADEIRA
■	Black	310	403	Black
O	Yellow	444	291	0106
♡	Blue	518	1039	1106
↑	Pale blue	519	1038	1105
K	Purple	552	100	0805
•.	Lilac	554	96	0711
8	Red	666	46	0210
\	Very pale blue	747	158	1104
▼	Dark green	909	923	1303
Ξ	Medium green	911	205	1214
И	Light red	3705	35	0411

FINGER PLATE

Steam press the completed embroidery on the wrong side. At each short end of the band, form and press a turning (checking that the finished length fits your towel neatly). Most towels have a strip of flatly woven fabric a few centimetres from each end, and the Aida band can be pinned and basted to one of these strips. Using matching thread and, stitching close to all edges of the Aida band, stitch it in place.

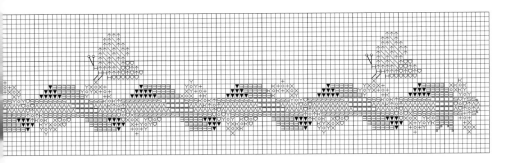

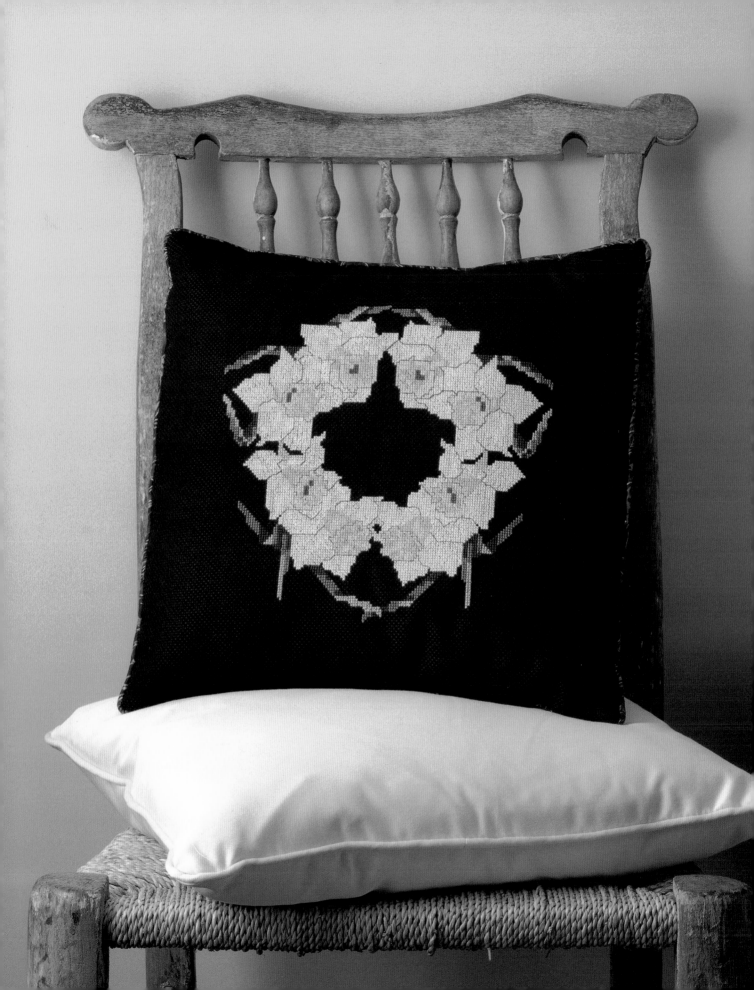

Daffodil
Wreath
Cushion

The cheerful yellow of the daffodils
shines out brightly from the black
background of this cushion,
bringing a breath of spring into your
home on even the darkest days.

DAFFODIL WREATH CUSHION

YOU WILL NEED

For the cushion, measuring 40cm (16in) square:

*45cm (18in) square of 14-count Aida fabric,
in black
Stranded embroidery cotton in the colours given in
the panel
No24 tapestry needle
Two 41cm x 35cm (16¹/2in x 14in) pieces of black
backing fabric
1.5m (1³/4yds) of piping cord
1.5m (1³/4yds) of bias strip, 3cm (1¹/2in) wide
Feather cushion pad, 40cm (16in) square or slightly
larger for a well-filled effect*

•

THE EMBROIDERY

Prepare the Aida fabric as described on page 4, marking across the centre both ways with lines of basting stitches. Set the fabric in a hoop or frame (see page 5) and embroider the cross stitches with two strands of thread. When all the cross stitching is completed, embroider the backstitches, using one strand of thread in the needle. When working on black fabric, it is important to work in good light and it may be helpful to place something light on your lap or directly under the work, as this makes the holes in the fabric easier to see. Steam press the completed embroidery on the wrong side.

MAKING UP

Fold the bias strip over the piping cord. Using matching sewing thread and the zipper foot of your sewing machine, stitch through the bias strip, close to the cord. Starting about two-thirds of the way down one side edge, lay the piping on the right side of the cushion front, with raw edges matching and with the piping eased around the corners. Baste in place. Where the two ends of piping meet, unpick the stitching of the bias strip a little at each end and

join the ends of piping cord, either by butting the two ends together or by carefully intertwining the strands. Fold under 12mm (¹/2in) on one of the raw edges of the bias strip and finger press. Place the other raw edge under this so that they overlap a little, enclosing the joined ends of the piping cord. Stitch the cord in place around the embroidered front cover.

Turn and press in place a 6mm (¹/4in) hem on one 41cm (16¹/2in) edge of each piece of backing fabric, and then turn and stitch a further 2.5cm (1in) on these edges. With right sides together, place the backing pieces on top of the cushion front, overlapping the hemmed edges in the centre. Stitch through all layers, stitching 12mm (¹/2in) from the raw edges and as close as possible to the piping, again using the zipper foot on your sewing machine. Clip across excess fabric at the corners and turn the cushion cover right side out; insert the cushion pad through the opening at the back.

▶ **DAFFODIL WREATH CUSHION**

		DMC	ANCHOR	MADEIRA
▪▪	Green	367	262	1602
←	Light green	368	261	1603
∧	Yellow	725	298	0107
○	Lemon+	727	293	0110
8	Light olive	734	280	611
S	Dark gold	783	307	2211
▼	Dark green	890	1044	1405
■	Dark brown	898	360	2003
+	Light gold +	3822	305	0108
	Very dark brown*	938	381	2006

*Note: you will require two skeins of lemon and light gold+; use one strand of very dark brown (*used for backstitching only) for all backstitching.*

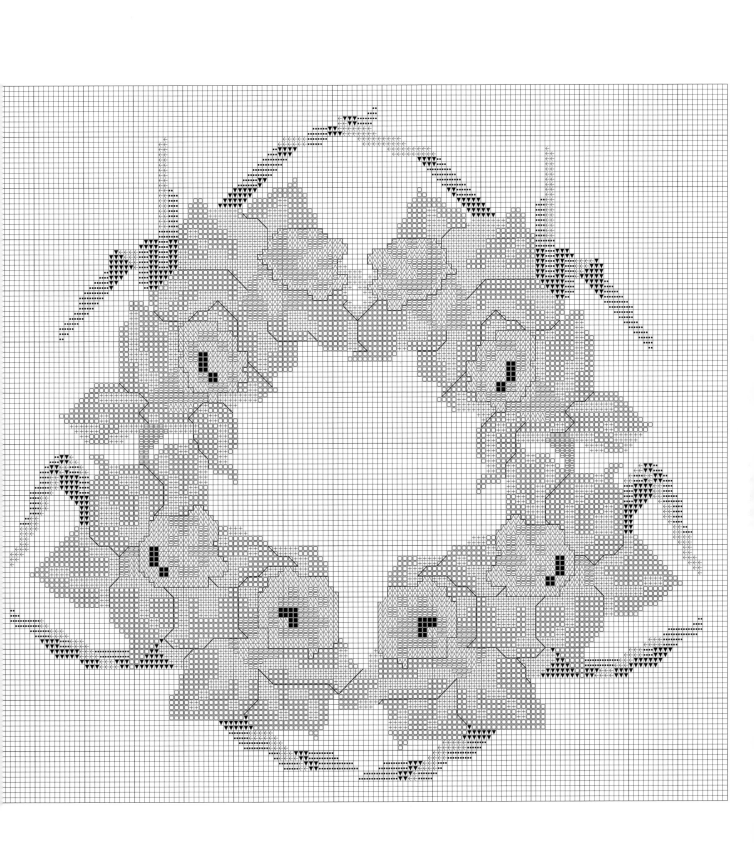

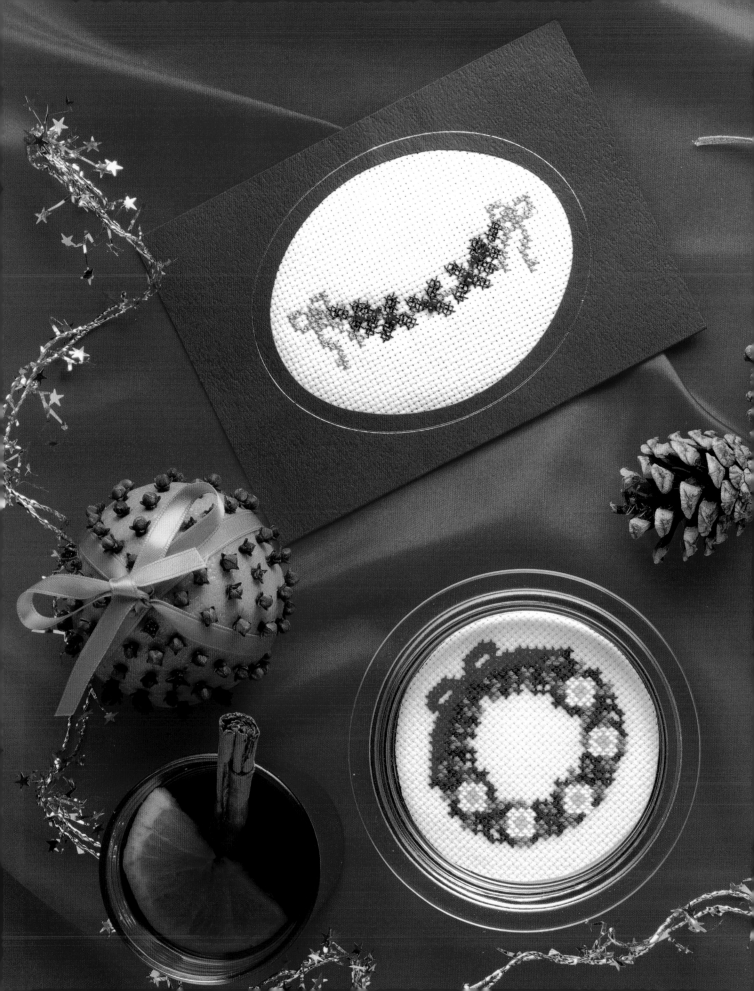

Christmas Wreaths and Garlands

Tiny wreaths and garlands are easy for beginners and perfect for decorations, cards, gift tags and many of the other small items you may need to prepare for Christmas.

CHRISTMAS WREATHS AND GARLANDS

YOU WILL NEED

For the coaster, measuring 11.5cm (4½in) in diameter, with a base with an embroidered inset 8.5cm (3⅜in) in diameter:

12.5cm (5in) square of 14-count Aida fabric, in white
Stranded embroidery cotton in the colours given in the appropriate panel
No26 tapestry needle
Glass coaster, as specified above (for suppliers, see page 40)

For the miniature framed picture, mounted in a frame with an aperture measuring 4.5cm (1¾in) square:

7.5cm (3in) square of 14-count Aida fabric, in white
Stranded embroidery cotton in the colours given in the appropriate panel
No26 tapestry needle
Miniature picture frame, as specified as above

For the gift tag, with a round aperture measuring 3.8cm (1½in) in diameter:

7.5cm (3in) square of 18-count Aida fabric, in white
Stranded embroidery cotton in the colours given in the appropriate panel
No26 tapestry needle
Purchased red gift tag, as specified above (available from art, craft or needlework stockists)

For the Holly Swag card, with an oval aperture measuring 10.5cm x 8cm (4in x 3in):

15cm x 10cm (6in x 4in) of 14-count Aida fabric, in white
Metallic threads in the colours given in the appropriate panel
No24 tapestry needle
17 red rocaille or seed beads
Fine beading needle and red sewing thread

Purchased card, as specified above (available from art, craft and needlework stockists in a variety of colours)

Note: DMC metallic thread has been used; there is no exact equivalent in the other brands listed, but you can use stranded embroidery cotton or other brands of metallic thread, provided you obtain an attractive effect. The swag design could be repeated on Aida band to make a cake band.

●

THE EMBROIDERY

For each design, prepare the fabric as described on page 4, marking across the centre both ways with lines of basting stitches. For the Christmas Wreaths, work all cross stitches with two strands of stranded cotton. For the Holly Swag card, work the cross stitching with three strands of metallic thread. The thread can be used as it comes from the reel or the strands can be separated and recombined to give slightly more coverage of the fabric.

For the Holly Swag card, thread a fine needle or a beading needle with red sewing thread or one strand of red stranded cotton and attach each bead with a half cross stitch (see below). Alternatively, work a cross stitch in place of each bead, using two strands of embroidery cotton or three of red metallic thread.

Assemble each of the items according to the manufacturer's instructions.

BEADING

Any cross stitch chart can be used for beadwork instead of stitching. Each square on the chart represents one bead, stitched onto an evenweave fabric, just as the crosses would be. The small seed beads are stitched onto the fabric with a fine beading needle threaded with a matching colour. Use a diagonal stitch (half cross stitch) to attach the bead. Make sure that all the stitches are worked in the same direction so that the beads sit evenly on the fabric.

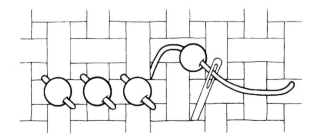

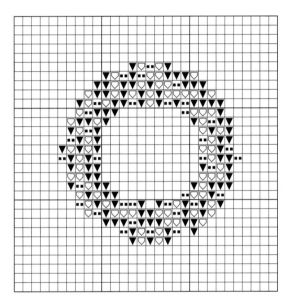

CHRISTMAS WREATHS

		DMC	ANCHOR	MADEIRA
•	White	Blanc	01	White
+	Yellow	444	297	0105
꛸	Red	666	046	0210
▼	Dark green	699	923	1303
♡	Bright green	703	238	1307

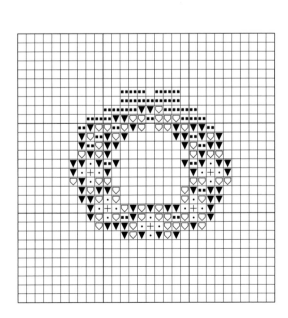

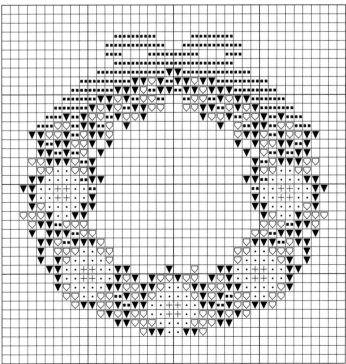

ACKNOWLEDGEMENTS

My special thanks to Penelope Jane Randall for her help with the stitching and for her moral support, and to Cara Ackerman of DMC for prompt and generous supply of threads and Zweigart fabrics. Finally, thank you Jim, Phil, Neil and Yvette for putting up with the bad temper, the strange meals, the messy, half decorated house and a lack of clean, ironed clothes.

SUPPLIERS

The needlework box kit (etui), wadding, cushion pad, piping cord, cotton fabric used in some of the projects, card blanks and machine embroidery thread were purchased from the company listed below (mail order available):

Quilts and Crafts
4 Allandale Road
Stoneygate, Leicester
LE2 2DA
Telephone: 0116 244 8889

The etui kit and other box kits are designed by Dylis Fronks (Dylis Designs) distributed by:

R.A. and P.A. Bolt
Swiss Cottage
Milton Abbas
Blandford
Dorset
DT11 0BJ
Telephone: 01258 880852

Framecraft Miniatures Ltd, listed below, supplied the burgundy trinket pot, glass candle holder, glass coaster and door fingerplate. Framecraft is a mail order company that is a useful source of supply for many cross stitch items, including blank embroidery cards, picture frames and linens.

FRAMECRAFT
Framecraft Miniatures Ltd
372-376 Summer Lane
Hockley
Birmingham
B19 3QA
Telephone : 0121 212 0551

Addresses for Framecraft stockists worldwide

Ireland Needlecraft Pty Ltd
PO Box 1175
Narre Warren M.D.C.
Victoria 3805
Australia

Danish Art Needlework
PO Box 442,
Lethbridge
Alberta T1J 3Z1
Canada

Sanyei Imports
PO Box 5,
Hashima Shi
Gifu 501-62
Japan

The Embroidery Shop
286 Queen Street
Masterton
New Zealand

Anne Brinkley Designs Inc.
246 Walnut Street
Newton
Mass. 02160
USA

S A Threads and
Cottons Ltd
43 Somerset Road
Cape Town
South Africa

For more information on your nearest stockist of embroidery cotton, contact the following:

DMC
(also distributors of Zweigart fabrics)
UK
DMC Creative World Ltd
62 Pullman Road, Wigston
Leicester LE8 2DY
Telephone: 0116 2811040

USA
The DMC Corporation
Port Kearney, Building 10
South Kearney
N.J. 07032
Telephone: 201 589 0606

AUSTRALIA
DMC (Australia) Pty Ltd
P.O. Box 317
Earlwood
NSW 2206
Telephone: 02 9559 3088

COATS AND ANCHOR
UK
Coats Paton Crafts
McMullen Road
Darlington
Co. Durham DL1 1YQ
Telephone: 01325 381010

USA
Coats & Clark
P.O. Box 24998
Dept COI
Greenville SC 29616
Telephone: 800 243 0810

AUSTRALIA
Coats Spencer Crafts
Private Bag 15
Mulgrave North
Victoria 3181
Telephone: 03 9561 2288

MADEIRA
UK
Madeira Threads (UK) Ltd
Thirsk Industrial Park
York Road
Thirsk
North Yorkshire YO7 3BX
Telephone: 01845 524880

USA
Madeira Marketing Ltd
600 East 9th Street
Michigan City
IN 46360
Telephone: 219 873 1000

AUSTRALIA
Penguin Threads Pty Ltd
25-27 Izett Street
Prahran
Victoria 3181
Telephone: 03 9529 4400